Thank You for This Child—Where Is the Instruction Book?

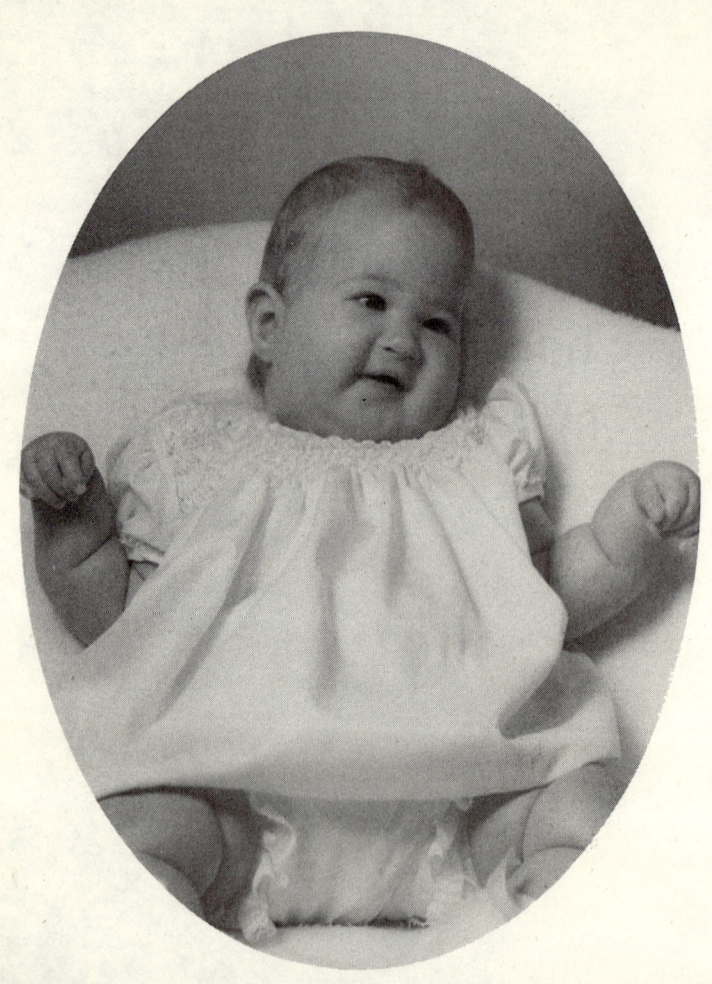

"Hello, World!"
Meet Kelli Alease Clodfelter

Thank You for This Child—Where Is the Instruction Book?

Martha H. Clodfelter

A Hearthstone Book
Carlton Press Corp. New York, NY

Copyright © 1995 by Martha H. Clodfelter
ALL RIGHTS RESERVED
Manufactured in the United States of America
ISBN 0-8062-5010-0

*This book is dedicated
to our daughter Kelli,
who has brought more tears
to our lives than we could
have comprehended, but more
than enough joy to overcome
the tears.* ♥

CONTENTS

Acknowledgments viii
Author's Note ix
1. A Beautiful Blossom, But a Weak Stem 1
2. Just a Little More Time, Please 3
3. Wait, Doctor, Somebody Has Made a Mistake 4
4. "I Eat Too" 8
5. Safe In Our Domain 9
6. But This Is Not What I Ordered for My Life 10
7. From One Decision to Another 13
8. A Church for All People? 17
9. Off to Camp! 19
10. Look Out Schools, Here Comes Kelli
 (and Mom and Dad)! 21
11. Who Will Tie Kelli's Shoes in the Morning? 26
12. One Year with the 'Empty Nest' Syndrome—
 Who Me? 30
13. But I'm Not a Lawyer, Just a Confused Parent 32
14. Daddy's Girl (from a Dad's Point of View) 35
15. Insights: A Look Back 39
 Contentment 42

ACKNOWLEDGEMENTS

Over the past twenty-six years of my life, I have had so many experiences, I often thought, and have been told, "You should write a book." I sometimes thought it would have to be presented as fiction because no one would believe it to be fact.

I have gained so much strength, knowledge, compassion, and maturity from parenting a special-needs child, I know of nothing I would rather do than to share and hopefully spare other parents some of the problems and frustrations we have gone through and to give them encouragement and hope.

Thank You—

To my best friend and husband, Gene, for his life's commitment to Kelli and me. His encouragement, stability, and faith have been my strongest force as another human.

To the very special teachers, therapists, counselors, ministers, and doctors we have been blessed with in every area of our lives.

To the very special friends and family that have stood by us and held us up emotionally and spiritually when we were vulnerable and weak.

Most of all to God, for making it possible and never failing us!

AUTHOR'S NOTE

Since all of life's situations are unique, this book is not intended as an instructional manual or a how-to book. This book is based on our family's experiences, trials and tribulations, and the routes we took in the raising and nurturing of our daughter, Kelli. ♥

Thank You for This Child—Where Is the Instruction Book?

1 A Beautiful Blossom, But a Weak Stem

On May 13, 1967, when the nurse placed a tiny, precious, golden-haired baby girl in my arms, I was overwhelmed with joy and pride and all the other "goodies" new mothers feel. I had no comprehension of what an impact and new direction this baby would have on my life and so many others.

Since the day Gene and I were married, we had planned and hoped for a large family as soon as possible. We had both been "only childs," and we longed for a family of our own. I enjoyed a perfectly normal and happy pregnancy. Gene and I enjoy doing things ourselves so we prepared the nursery, first, by rebuilding and refinishing the baby bed that I had slept in as an infant. By the time I was seven months pregnant, the nursery was complete. It was beautiful, yet simple and practical. I had even placed animal decals on the pull-down shades to match the coverlet in the crib. Gene wallpapered the walls in coordinating colors. He refinished a lovely white baby dresser. I had made a beautiful ruffle to go around the bassinet, each stitch made with love and great expectation of the joy soon to come to our family.

As nature is unpredictable, the baby was two weeks late. On that Saturday morning, May 13, 1967 just thirteen hours before my own birthday (it also came on Mother's Day that year), God blessed us with a most beautiful baby girl. She was endowed with a head full of golden curls. The doctors and nurses remarked that even they had never seen such beautiful hair on a newborn baby. It had a frosted glow to it. Because there was only four pounds and eleven ounces of her, she had to be placed in the isolette for twelve hours. The pediatrician assured us she was normal in every way, just genetically small, like her mother.

We decided to name our little angel Kelli Alease. Our first three months at home were the happiest anyone could have. Kelli was such a good baby and so pretty. Everyone complimented us and we were so proud. In time, we wanted other children, but for now Kelli was our world. I enjoyed staying home, devoting my time to Kelli and being "Miss Suzy Homemaker."

2 Just a Little More Time, Please

When I took Kelli for her three month checkup, her weight had increased very rapidly and the pediatrician was very pleased. However, he became concerned because she would not hold her head steady. Nor would she put her feet flat on a surface, when held erect. We were not too alarmed, considering her small birth weight. At four months she still could not hold her head steady, could not put her feet flat on a surface, and made no attempt at sitting. The same was true at five months. Finally, at six months, she could hold her head steady. Still, her attempts at standing and sitting alone were futile. She cooed, smiled, and did all the other things a baby does at this age. The doctor remarked about how alert and responsive she was. When it came to her muscle control, she was so far below par. She had trouble holding a rattle or toy. She always seemed to grasp everything from the side, rather than going for it directly with her hands.

Every day the burden became heavier on us as new parents. When I saw other babies, I could not keep from staring to see what they could do and then I would realize how weak my baby was and how far behind in her development. I had been told, numerous times, not to compare babies. I told myself I was not comparing, just "checking out" the other baby's development, (to compare Kelli).

3 Wait, Doctor, Somebody Has Made a Mistake

At Kelli's eight month checkup, she could sit momentarily and we were so pleased. Her efforts at standing were still hopeless. "Well, she will just catch up," we kept telling ourselves. At this visit, I asked the pediatrician if he suspected any major problems to please tell us what they were and where to go for help. He would not look at me, but responded, "I think you know this baby will never be all that you want her to be." I felt all the life drain from my body and soul. When your baby is nine months old, the last thing you want to hear is that she will not be normal. My first response was, "Where can we go and get help for her?"

He recommended that we take Kelli to a child development clinic. There she could be examined by a neurologist, a physical therapist and a child development "expert" (if there is such a thing). The appointment was made as soon as possible. We must have lived a thousand years in the next two weeks. My heart was so burdened, I felt as though I could not and did not want to live if there was "something wrong" with my baby. I searched through dictionaries and any books I could locate to find the symptoms of various muscular diseases as well as mental retardation. Before my pregnancy, I had worked for an orthopedic, so I could understand some of the "big words" I found. Of course, we came up with a thousand answers for Kelli's problems.

All of this time I was convincing myself if we could find a diagnosis or a name for Kelli's problems, we could surely just find a doctor and he would give medication, surgery, therapy or whatever it would take and we would "fix it." I now know that it is not uncommon for parents to want a "label" or a "diagnosis

with a name." If there is a name for the problem, it may be cured or at least helped. Maybe we want a diagnosis rather than being realistic about the child's potential.

At last, the day came for Kelli's appointment with the clinic. Gene and I tried to see through the doctor's examination to detect what they were looking for in various tests they would perform. Kelli always enjoyed people and so for her it was all games and fun. When they finished the examination and talked with us, we hardly knew any more than we did when we came. In some areas of her development she was up to par for her age; in other phases, she was like a three month old. The medical term the doctors kept using was "benign infantile hypotonia." This simply means low muscle tone with no apparent cause. The doctor, who seemed to be a very devout man, said all we could do was go home and pray and hope and bring her back in nine months. He said it was just too early to be sure of a diagnosis.

We did go home and hope and, above all else, we prayed twenty-four hours a day (sometimes more) that Kelli would outgrow whatever this "thing" was and she would live a normal life. Every day I became more and more depressed, and the burden grew heavier. It seemed as though I could not even do the necessary things for Kelli's welfare without a lump in my throat and my eyes full of tears. Everything she did or did not do, I would analyze and ask myself, "Is that normal for a baby her age?" Needless to say, I was missing out on the enjoyment of her as a baby and as an individual. What would any new mother do? Every time I looked at her, I was wondering: Will she ever walk? Will she be an invalid all her life? Is she mentally retarded? Will I be able to take care of her at home? Will she be able to go to a regular school like other children? Will she live a normal life span? I guess one of my worst thoughts was that if she was mentally retarded I could not deal with it. If it was something physical, maybe they could "fix it," but not mental retardation. Of course, there were no sure answers to any of these questions.

At nine months, back to the clinic. After the examination, we were told no more than the last visit. The doctor did explain to us on this visit that the nearest description he could give us of Kelli's weaknesses was a form of cerebral palsy. He said usually cerebral palsy came from a definite injury to the brain. Kelli showed no signs of this. She had the symptoms of cerebral palsy but not the cause. (Cerebral palsy can be manifested by "spastic" or "floppy" muscle

tone.) At this time she could roll over and sit alone very well. He was pleased with her progress from her waist up but not in her legs. Her efforts at standing and weight-bearing were hopeless. We were told to bring her back in one year.

In the meantime, we had changed pediatricians. I guess our decision came from the original pediatrician's not telling us the truth in the beginning. Now I can look back and realize the pain he must have gone through, too. Here was the first baby to a young couple, and the first grandchild on both sides, a baby absolutely adored by the family. Now he had to be the "bearer of bad tidings" and tell them that their child is never to be what they wanted or expected. He must have felt tremendous pain himself. This was a baby that he could not make "better"; doctors are trained to make people's problems get "better" and he could not. Yet, in our minds, as parents, we felt if he had not told us the truth he suspected from the beginning, how could we trust him to tell us the truth in the future? Maybe we would always wonder about everything he told us later. As was our blessing, we found a wonderful "fatherly" pediatrician. He took extreme interest in Kelli and us as parents to this "less than perfect" baby.

During all this time of testing and waiting, the doctors had discovered that Kelli had a serious vision problem. We took her to an ophthalmologist who told us she was extremely near-sighted and that one eye drifted to the center. He recommended she be fitted with glasses at fourteen months. It was quite interesting for the optician to fit glasses for a baby's head that was probably no larger than a large grapefruit. We were blessed with a very knowledgeable and patient optician and ophthalmologist. The lens in her first glasses were about the size of a nickel and about 3/4" thick. She was fitted with a band to hold the glasses on. It was evident Kelli knew she was seeing better with the glasses than without. She did not need the band to keep them on. Of course, in years to come, as she was able to get around, she fitted her glasses on her pet dachshund and cut all her teeth chewing on the side pieces. It was hard to convince the optician that these were Kelli's teeth marks on the glasses and that they had not been chewed by a vicious dog.

In order to try to increase the muscles of the weak eye, at about eighteen months, the doctor patched Kelli's strong eye to try to strengthen the weak eye's muscles. With finances already strained to the limit, we did not have air conditioning in our lit-

tle five-room house. For Kelli to wear a patch on her eye in July, with temperatures soaring near 100 degrees, caused tremendous sweating under the patch. When she would cry, the tears would well up under the patch. It was very uncomfortable to say the least. To the rescue, came Grandpa with a window air conditioner. This helped immensely. When the patch was removed, it was discovered it had done no good at all in strengthening the weak muscle.

At nineteen months came our first surgery. The doctor clipped the muscle that was pulling the weak eye to the center to make it match the strong eye. When Kelli came out of surgery, with all the bandaging the surgical ward could muster to put on a tiny eye, she was not in the least happy with her new "attachment." She was so hard to control to keep from tearing the bandages off, they finally resorted to a child's "restraining-jacket." This was to no avail. Kelli simply pulled herself through the bottom of it and came out. Gene and I and the grandparents took turns just holding her in our laps around the clock to calm her down until the doctor removed the bandage. Kelli was so young, it was almost impossible for any doctor to know exactly what she was seeing or how she was seeing it. She had found that the easiest way for her to grasp any object was to swing her arm out to the side and grasp it. She seemed to be more sure of herself in finding what she saw. In years to come, we would find that without her glasses, Kelli was probably 90 percent blind.

When Kelli was only about eighteen months old we took her to the dentist just to let her watch him work on our teeth. We found that was to help her later to trust him and let him work on her teeth. Trust is so important to the special-needs person. Even though they may not be able to be as verbal as we can be, they certainly have body language and eye contact understanding. This is probably deeper than we, as normal people, have. Kelli has been blessed with excellent rapport with her doctors, her dentist and optician. She trusts them and this is most important with her.

4 "I Eat Too"

We were still anticipating another visit to the child development clinic. It seemed as though all we were told everywhere was "Wait-Wait-Wait." Sitting on the fence for months when it concerned my dearest, did not appeal to me as joy. In all of our plans, I tried to arrange things so that Kelli would not be in a position for questions or stares because she could not do the things other babies did. When I would take her to sunday school nursery and see babies younger than she practically walking, and my baby so limited, I wanted to just pick her up and run and not stop. Of course, that was not the nice thing to do in church. Sometimes church can be a very painful place to be. Everyone is trying to be their best and look their best. If appearance doesn't fit the "church's mold," people can feel very alone there.

On leaving the church one Sunday, a lady, dressed extremely well with her furs, surveyed Kelli's appearance. She asked Gene if this child was spastic. With true Indian blood in me, I informed her that the child was not spastic, but the mother could be if made angry about her child.

We had so many episodes of "public ignorance." Once in a restaurant at Christmas, the owner, dressed in a Santa Claus suit, was going from table to table giving out candy to all the children. When he reached our table, he kept going and ignored Kelli. "Big Daddy" (Gene) proceeded to get up, follow him, and say "My daughter wants a sucker too." Needless to say, Santa's face was as red as his suit. She got a handful of suckers!

Once in a shopping mall where a new delicatessen was being opened, someone was giving out samples of cheese and crackers. Gene and I were treated to the samples while Kelli was ignored. In her limited speech she said, "I eat too." She got cheese and crackers!

5 Safe in Our Domain

At home alone with Kelli I was happiest because there were no stares or questions. She was the happiest and most beautiful baby I had ever seen. Not only did we think so, but so did everyone who saw her. One friend gave us consolation telling us that whatever Kelli could not do physically, she made up for in her pleasant personality and disposition.

Kelli had even more golden curls now and could say "Ma-Ma," "Da-Da," and "coke." We had bought everything on wheels or rockers to encourage her activity. In a walker, she would push backwards rather than forwards. Any attempt she made at crawling was backwards. Her first year birthday party consisted of only relatives. I could not punish myself by inviting other children to our home and watching them running around and Kelli just sitting and watching.

During this first year, we had so many joys that all new parents experience, but there was always the "cloud" hanging over all our activities. We certainly grew in patience as well as maturity ourselves. I now begin to think of Kelli as a precious gift, as all children are. Not knowing what the future held for Kelli or us brought a lot of untold anxiety and questions to us as new parents. As I watched other mothers tending their babies, I began to wonder, Has she ever thanked God that her baby can sit alone? Has she ever thanked God her baby can stand, can crawl, can pull up, can see, can hear, can hold his bottle? Kelli was nine months old when she was weaned and never held her bottle because she lacked the proper coordination. How my heart yearned to see those pudgy little legs toddling around. She was easy to toilet train, because she could not stand a dirty diaper. She would crawl to the bathroom and pull on her diaper to get it off.

6 But This Is Not What I Ordered for My Life

It was time now for another evaluation at the development clinic. We were more comfortable with the doctors and therapist now. They had asked every question known to mankind about family history. It was after this evaluation that the neurologist told us to just go home and decide where we wanted to "put" Kelli. She would never walk, talk, be toilet trained, never know who her mama and daddy were. He said we were fortunate to have had her a year. Most babies with such weak muscle tone and so developmentally retarded would not have made it a year. That led us to believe that she would never live a normal life span. He said we should just make these decisions and go on with our lives. How could we go on, when Kelli was our life. Gene told him we would go home but we would not be back there. With that statement, the doctor's desk was rocking.

After this evaluation, if my life could have just ended, I would have felt peace. Years later, I can look back and see that we probably took our anger out on the doctors because they were not telling us what we wanted to hear. The doctors, however, could have used a little more tact and compassion in telling us such a diagnosis. He gave her the same labels: cerebral palsy, benign infantile hypotonia, and now mental retardation. That was the worst fear I had. I knew that could not be "fixed."

In the months to follow we were to go through all the stages of grief. The child that we had expected and planned for never existed. There is the shock stage: "This

can't be happening to me. This only happens to other people." The anger stage—even at God. If you are angry at Him; (and I was), you may as well tell Him. He already knows it. The guilt stage: "Whose fault is this? Where can we lay the blame?" The denial stage: "We'll find a name for this and somebody can make it better." The child that we had expected and planned for never existed. It was a chronic grief—never ending. We are created to cope with grief in death, which is a normal, expected, experience in life. This was a chronic never-ending grief. This is not the kind of grief we normally deal with, but rather a kind that is ongoing, not final.

I guess we raised every question known to man and to God. Why, when so many people every day have perfectly normal babies and do not want them and throw them in trash cans and abuse them, could we not have a normal, healthy baby when that was all we wanted? To this day, I cannot find a satisfying answer and never will on this earth. I do not believe, for one second, the cliche that God gives special children to special parents. This is one heck of a price for my child to pay if I am special (and I'm not). All children are special. All parents deal with these problems in different ways. We went through the guilt. "Whose fault is it?" We searched back through our family's history to see if there was "bad blood" anywhere. Sometimes one parent may blame the other for some inherited trait along the way. This is probably true with grandparents as well. We came to the realization that life would never be the same and not what we had planned for. What we did do was finally accept this fact, as much as we could. Accepting this does not mean we approve of it or like it. It does mean that we reached the point that we could honestly say to ourselves and the world, "IT won't be better, IT won't outgrow this, NO doctor can fix "IT;" life will never the same but life does go on. What can we do with the abilities Kelli has and where do we go for help?"

The ensuing years brought so many trials in ways to help Kelli, first, to walk. Our house sometimes looked like a gym. Gene made a child's walker out of aluminum lawn chairs. He made parallel bars in the back yard for her to hold on to try to hold on to to try to walk. Every day brought endless hours of standing Kelli up in a corner of the dining room and coaching her just to walk an inch (or less). We bought or made every toy, every apparatus on wheels or rollers we could find to encourage her activities.

Because Kelli's ankles were so weak, she was fitted with short-leg Phelps braces. That in itself was a new challenge. We made many trips to the brace shop to repair the chews and tears on the straps where Kelli had given the dog the braces to chew on. There were many pressure sores on her tiny feet and legs from the rubbing. We went through many packages of lamb's wool. The braces were so heavy and Kelli was such a tiny little girl. She could hardly pick her feet up.

One of Kelli's strongest characteristics is her determination. She would never, never give up on anything. When she finally pulled up and could walk holding on to our fingers or the furniture, if she fell, up she would come and try again. Her determination gave us strength to keep trying ourselves. Yet there is no way to describe the pain we had in our hearts and minds every hour of every day. Kelli was such a joy to be a parent to. She seldom cried or had temper tantrums; she was a very happy child. However, she had a mind of her own. When I would try to make her eat the foods that would aid in her chronic constipation from weak muscle tone, no vise could pry her mouth open.

So many frustrations. It seemed we had a new one to deal with every day. During this time we were getting private speech therapy for her. Whether this helped her speech or not, we will never know. We just knew we had to leave no stone unturned to get help for her. We tried so many "tongue exercises" to get the "la-la" sound without success. Finally we put peanut butter on the roof of her mouth and as she worked to get it out with her tongue we would get her to produce the desired sound. When you have a child like this, you find out that speech, walking, and most other functions that we do automatically and take for granted are actually made up of many small actions put together. For these children, you have to learn to be creative in helping them learn each of the smaller parts before you can put them together to arrive at the finished product. We were fortunate to become associated with some bright and innovative people who helped us learn to be creative ourselves as we continued to work with Kelli day by day.

7 From One Decision to Another

Then came the day when the pediatrician said Kelli needed to be in a kindergarten with other children. She had been so protected. Our family had been her world; I wanted just the right school for her. I had no idea no school really wanted her or was willing to take her, even on a trial basis. I went through the yellow pages calling one kindergarten after another, only to hear excuses why they would not take a handicapped child. Most of them used the excuse that their insurance would not cover her. She would be more likely than the others to have accidents. She would not "fit in." I could not understand how so many schools were listed in the yellow pages under "Christian Schools" and yet here was one of God's creations needing their services and they were not willing to give her a chance. In retrospect, it might have helped if we had suggested that we as parents would sign a release form to take care of the insurance. Finally, I received a positive response from the nearby Montessori school, which was operated by the local Catholic church. The director said she would take Kelli on a one-week trial. That was all I asked. I was so excited, I forgot to ask the cost of the school.

Before Kelli was to begin school, the teacher prepared the children in a marvelous way. She drew leg braces on the black board and explained to them that a little girl was coming who would be wearing braces and would have trouble walking. They were not to help her unless she told them to. She explained to them about Kelli's glasses and that she had poor speech compared to their abilities. The children were prepared by this exceptional teacher and accepted Kelli in a remarkable way. After the first week's

trial, no way the director was about to tell me Kelli could not continue. The children and teachers had fallen in love with her and she with them.

After Kelli's first year in Montessori kindergarten, she had made so much progress, we asked if she could stay an extra year. The school agreed, and, Kelli stayed in kindergarten until she was seven years old. It was the first real socialization for Kelli to just be "one of the kids," and it proved to be a very rewarding experience for us and her. She was invited to all their birthday parties, etc. No one really treated her differently, except that when she could not do things the others could, the teacher would supervise. I think we would have kept her in Montessori until she was twenty-one years old if we could have. During these first five to seven years of Kelli's life, it seemed we only went from one decision to another. While this kindergarten teacher and the other children in the kindergarten accepted and befriended Kelli, it was evident she was certainly going to need more help on a one-on-one basis from many specialists. While on a business trip to New York, Gene was introduced to another gentlemen from that area who said his wife was doing some research work in Chapel Hill, North Carolina, that sounded like the type of program Kelli might need. He gave us the name of the doctor who was directing the TEACCH program at the University of North Carolina. We made the first appointment we could get, without any referral from a doctor or teacher.

This contact was to prove to be one of the most helpful and most encouraging we would have for some time. Kelli underwent another "complete" evaluation. The atmosphere and attitude of this program was never focused on what Kelli could *not* do but on what she *could* do. If she was weak in one area, they would simply try to find a strong area and work on that, rather than focus on the weak points. Kelli had trouble sitting and handling objects with her hands. They found through trial and error that if she was supported in the back of her trunk, she could maneuver her hands better and be more stable. By not having to support her back, she could put all her energy and attention on what she was trying to do with her hands. The letters TEACCH, stand for "teaching and educating autistic and communication handicapped children." Kelli did not fit the autistic "mold"; however, she did have some of the characteristics as well as the communication problem. They discovered her hands "mirrored:"

what one hand did the other did simultaneously. This probably came from some center-line brain damage. She also did the "flapping" of her hands that is common in autism.

It was during these evaluations and testings that we underwent extensive genetic, chromosome and gene evaluations. This was to no avail. The most probable cause of Kelli's brain damage was her being in the birth canal too long before delivery. Just finding a reason for the damage does not make dealing with the problem any easier. We were looking for some satisfaction for ourselves, I guess.

For months the therapists in this program would outline a "home program" that we would work on at home every other day. We went to Chapel Hill the alternating days for them to watch us work with Kelli to be sure we were following her program. (This was during the gas shortage in the early '70s.) One of her weakest areas at this time was her speech. The therapist suggested we try to teach her sign language. We were very hesitant to try this, afraid she would not try to speak if she could communicate with signs. It was explained to us that if we would say the word as we were signing to Kelli and she learned it that way, signing would not interfere with her verbalization. We found this to be true. Kelli learned to sign quite well before she could talk plain enough for outsiders to understand. We would later learn that Kelli would automatically drop the signs when she could be understood verbally. This proved to be a very effective way to encourage her speech.

During this time Kelli was having continual battles with strep throat infections. Finally the doctor decided to remove her tonsils. Her mouth was so small, he said he felt sure he could remove a bird's tonsils after removing Kelli's. Because of her weak muscle tone, she was placed in an oxygen/steam tent for about forty-eight hours. This only scared her more. The more she cried, the more she bled. Finally, when all else failed, I got in the oxygen/steam tent with her to calm her down. Now we were both "caged"—and it was a disaster for my hair—but at least her crying stopped.

After Kelli had recuperated from the tonsillectomy, we discovered there was such a void in Kelli's throat from her tonsils being so large, she had lost all her speech except for the words "mama" and "coke." Back to square one; we started with the speech again. Chapel Hill would make the flash cards with the

sounds she was to learn to make again. We would sit for hours, sometimes with a mirror for her to see herself, making "weird sounds"-SSS, La-La-La, Tru-Tru, Ka-Ka-Ka, etc.

What little things parents take for granted—until their child does not have them. During these times, we were very much aware of the stares and blank expressions Kelli was getting from people. Apparently, a lot of the public was trying to get an education from this tiny little girl with thick glasses and leg braces. It is amazing how much kinder people could be if only they would educate themselves to the people around them that do not exactly fit society's mold.

Once, in the grocery store, Kelli was sitting in the grocery buggy. When I started to take her out, her leg braces got caught and I could not get her out without hurting her. I turned the buggy, child and all over to get her out. Needless to say, there was quite an audience, but no "help."

During these years, I guess we finally reached the point that the stares only proved to show to us how ignorant some of society is. The worst thing about this ignorance is that a lot of them choose to remain that way. What people do not understand, they tend to stay away from. If they are uncomfortable with a situation or person, they stay away from it. Sometimes they do not wish to be educated. The same is true with crude comments people can make out of ignorance. We once had a person comment, "Well, the poor little thing would be better off if she had died at birth."

8 A Church for All People?

We like to think that—right? When Kelli was a baby, to fit into the nursery at church was no problem. As she grew and was unable to walk and talk like the others, she was a "misfit." When we starting investigating other possibilities, there were none.

We discovered that most of the parents of special-needs children, simply stayed home from church, because it was easier. We asked and encouraged our church to begin a special education Sunday school class. There were certainly other people with similar problems in the neighborhood. The church's response was that there was no one in our church trained in this area. I always questioned what training we as parents were supposed to have had! As Kelli grew older, we were told she could just "sit" in the nursery. No one wants to go to church just to be tolerated. It was at a local American Red Cross meeting that we met a gentleman from a neighboring church who asked if we would support a special education class in the church for which he was Minister of Education. There was one other family in the community he felt would be supportive.

At that time, we changed our church membership. The decision was painful, knowing our church was not willing to provide for our child, simply because she required a little more time and patience.

The acceptance and attitude of the special education class in our new church was reflected from the pulpit down through the congregation. The teachers had no special training, simply unconditional love, despite sometimes unlovely situations. Our church staff was totally supportive. The class grew through the

years. Most parents had been so accustomed to staying home from church because they could not tolerate the stares and knowing that people were uncomfortable with their child. It was hard (and still is) to convince them otherwise.

9 Off to Camp!

During these years, probably ages seven and up, Kelli's teachers and therapist encouraged us to let her go to camp in the summertime. At age seven years, she went to a summer camp in a nearby city. When we went to get her on Friday (after a painful week for us), we were told she was so unhappy, she tried to jump out a window to come home. This proved to me "Mother's instinct" is sometimes more correct than the professionals.

We waited a few years before we tried summer camps again. This time, it was a wonderful experience. We selected a state Easter Seal camp. I made numbers of calls and inquiries as to the staff ratio and their training. I did not feel Kelli was ready for another full week away from home. After talking with their headquarters, I was told they only accepted applicants for a full week's stay. We reached an agreement that we would pay for a week but Kelli could come home by Wednesday. In this way, she could gradually become independent of home and she did. Summer camps proved to be a happy experience for Kelli and for us. We were so proud of her. This helped her feel good about herself as well. This also gave us some time for ourselves to vacation doing things Kelli did not enjoy. During these summer camps, she had wonderful experiences riding horses, swimming, etc. The counselors were usually young people who planned to go into some type of work in special-needs areas. Sometimes in the summer she and a friend would go to "buddy camp" (a handicapped with a non-handicapped child). Later some of these "buddies" would choose careers in special education areas.

During these years, the North Carolina State Baptist Association saw a need to start a summer ministry in camping for individuals with specials needs. This ministry has grown to be a real happy experience for Kelli and others. Gene and I have served on the staff, directing arts and crafts, since the beginning.

From this ministry grew the awareness to educate other churches and make them aware of the possibility of other Sunday school classes, vacation Bible schools in the churches.

In 1982 the State Convention decided to make a video entitled "No Longer an Attic Child," with Kelli as one of three North Carolina people to be featured in it. The filming crew was with us daily for a week. This came after Kelli's decision that she wanted to join the church. While teachers are teaching and preachers preaching, Kelli may be staring out a window, but at some point she was understanding and comprehending what she was seeing and hearing. When she told us she wanted to join the church, we were not concerned that Kelli had to join a church. Our feeling was, if it makes Kelli feel good about herself and feel more a part of the church, it was her decision.

One of the features in the video was Kelli's baptism. The filming session was set for Sunday afternoon at the church. The pastor asked the congregation for some volunteers to sit in the pews to help re-create the joining of the church and baptismal scenes. We were so proud of our church, and the filming crew was totally surprised. Half the parking lot was full of cars and the church was about one quarter full. The filming crew thought that there was another function going on at the church, but there wasn't; they had all come to support Kelli in this film. This showed the support for this special ministry by the entire church. Teachers and workers in this ministry must be creative. Think of the parents as well as the child. These people may be tired of preschool literature and "Jesus Loves Me." This may hurt the parents more than it helps the handicapped person. It only puts salt in that old wound once again.

I never question Kelli's faith. It is so simple and real to her. She prays for everything and everybody and just assumes she will be answered. We have had very-much-prayed-for dogs and various others pets. Recently on a trip to the beach, Kelli's prayer was, "Dear God, thank you for this beach and for potato chips and don't let it rain. Good night, God." When someone dies, Kelli simply asked, "Gone to heaven? When we going?" She has an inner strength and faith that cannot be questioned. It is simple but real. Once when she had foot surgery and was so restless at night, I told her to calm herself by saying some of the twenty-third psalm. In the darkness of her bedroom I could her mumbling: "'The Lord my shepherd.' Mama, it ain't working, my foot still hurts!" Where are you Bible scholars when we mothers need you?

10 Look Out Schools—
Here Comes Kelli
(and Mom and Dad)!

When school bells ring for the first time for children, different emotions stir in all mothers. We were about to enter a whole new world for us and Kelli.

The Law PL142 was being exercised to the fullest, for which we were so grateful.

I scanned all connections I could find for the references to the best teachers in the school system. Fortunately, we were off to a good start because Kelli's first teacher was exceptional. This was both good and bad. We expected all teachers and therapist that followed to be the same. We were in for some education and rude awakening ourselves!

Since Kelli was the smallest in her class, I was always fearful for her safety. This was her first experience in a public school interacting with other children from all types of home environments. Some of the other parents wanted to be involved and others did not. Some of the children were quite verbal and others were not. Kelli was using some sign language, and we were anxious to have help from someone who understood her yet encourage her to verbalize.

In the early school years, we were to encounter situations we had never had before. Some of the students were from such harsh backgrounds, they knew how to survive by any means of force. Kelli knew nothing of this livelihood. (Neither did Mom or Dad!)

All this time busing was in full process. That in itself was an experience. Once on a school bus, with a student with some harsh behavior problems, Kelli was bitten so badly by this student, she had to be given tetanus shots. Race has never been an

issue with Kelli. She sees no color in anyone, and that is how we trained her. One of the best and most unusual teachers she had was a black lady who was the first to show us how music could be so important to Kelli. After lunch in her classroom, for about thirty minutes, she played soft classical music. All of the children responded in such a positive way. This tone of music always had a calming effect on them.

We encountered many new experiences, simply from school buses alone. Since the special education population was smaller than the normal population, Kelli's time on the buses and transferring was un-thinkable for a normal child. I drove many miles for many years so she could avoid spending hours on buses.

After several episodes of such misbehavior as we saw, we made our presence known at many school board meetings. There is strength in numbers, but there were always just a few families getting involved in special education for one reason or another.

Monitors were finally assigneed to the buses, which was a tremendous help. Kelli needed the independence from our presence as much as she could. Her tiny little legs could barely make the steps but she never gave up going up the bus steps. She thought she was as big as the biggest guy on the bus.

As in any person's school years, we encountered different personalities in teachers. *Why* do people teach special education? For many different reasons. We met a lot who were in it to compensate for lack of their own self-esteem: to help those "less fortunate" made them feel good. Others for the right reason—to teach and help another human being realize his or her full potential.

We found some teachers want parents to be involved and some do not. If parents are not involved, they are not aware if a teacher is efficiently doing his job or not. Therefore, the teacher does not feel threatened or challenged. One of Kelli's worst problems was a lack of motivation, yet she has always been very determined. How do you distinguish lack of motivation and laziness? Kelli never had to be concerned about why she should try to read or write. It is not important to her; how do you motivate someone to learn something he sees no reason for? To Kelli, "Why?" is not a concern. She assumes every minute will be O.K. She has never had a concern to worry.

Opposite of the teachers, who do not want parents to get involved because they feel challenged or threatened are the ones

who want parental involvement. You may find very few parents of special needs students who want to be involved; a small number of parents carry the load. Sometimes when you do get involved, the staff seems to think you are overprotective. Parents of special-needs children are always on a thin-line wire. You have to reach the point you will do what you feel is best for your child and not be concerned about the public opinion, and that is hard. Discipline is so important in the development of the special-needs people. Parents are always "on the line," and being watched and scrutinized. If you are in a group of people and you discipline your child, there is one who will say, "How can they discipline that little thing? She doesn't understand." Then there is always the other onlooker, who if you don't discipline them will say, "Why don't they discipline that child? She understands what she is doing."

You have to reach a point that you discipline and correct to the limit that is understood by the child. Just as with a normal child, if there are no limits or discipline, you are cheating the child of becoming a person that society can, somewhat, accept and like. We have found that if we explained to Kelli when she was disciplined what the rules were, she was less confused and more at ease in knowing what was expected of her. When they are children, it is easy to forget that someday they will be adults, maybe not "normal adults," but society has a right to expect them to be as nearly acceptably socially as possible.

While Kelli was in the school system, we had many challenging experiences. Among these was the concern of the dedicated staff in Chapel Hill to Kelli's classroom situation and how much individual attention she was getting. Their interest was shown when they sent personnel to observe Kelli in her routine daily activities. After making their observations, we met with teachers and staff. It was quite obvious one of her teachers was more interested in watching her watch and reminding us what time she had. It was obvious she thought we were just wasting her time. When you are unfortunate enough to get a teacher like this, especially if she has tenure, you are always on the defensive. Their primary concern is to serve their time and make their money, with no real interest in the student. One of Chapel Hill's observations was that because Kelli was not a behavior problem and did not demand attention, she was not getting her share. If a teacher has students who are demanding and behavior problems, of course, the well-behaved are neglected. At times, Kelli was just

being tolerated. In testing and teaching these individuals, professionals should consider that maybe they are tired and bored with putting pegs in a board. Who would not get tired of putting pegs on boards or collating items for twenty years. They have tried and failed (in some cases they have succeeded) at the same task over and over so many times, that it is hard to generate any enthusiasm. Creativity in activity may be the path to help them achieve their goals.

Kelli's sixteenth birthday was particularly hard. I guess because this seems to be a milestone in most of our lives but for Kelli, this could not be. For this birthday, we took her to Disney World. I remember being up early in the morning and watching a mother bird feed her babies. I resented that bird so much for having normal babies, I threw a rock at her. These are true deep feelings of anger and maybe not all parents of handicapped admit these feelings. However, whether we admit to them or not, they can and do raise their ugly heads and we have to deal with these feelings. Kelli could not get her driver's license, for example. I am one who can "justify" whatever I want to do. So that Christmas I bought her a white fur coat and justified it by saying I could not buy her a car. Birthdays and holidays are always hard if you do not have the happy, "'round-the-Christmas tree" type of family setting.

Kelli (and Mom and Dad) did survive the school system and she graduated from special education classes at twenty-one. Her junior and senior years were highlighted by the prom. We probably made a big deal out of this more for ourselves than Kelli. I never attended a prom and was determined my daughter would. The school did an excellent job of planning this lovely event. Kelli wanted to invite a special friend she had grown up with. We and his parents enjoyed dressing them in full formal attire, taking them to a nice restaurant for dinner, then leaving them at the prom.

The prom and her graduation were both exciting and depressing. We were determined she would take advantage of every opportunity to enjoy life and we did.

Her graduation was very special and well-planned. However, my thoughts kept coming back: What now for Kelli? Is this all there is? Her gait was so unbalanced, she was escorted to get her diploma.

As always in Kelli's life, whatever she has needed, appears only at the time she needs it. The sheltered workshop in our city opened a new workshop close by. Kelli was one of the first clients. For several years this served a real purpose in Kelli's life. Transportation was again a problem. We appealed to the public transportation to no avail. Public transportation was available for the elderly but not for disabled who lived at home. Mom's taxi service again operated twice every day. We could find no other reasonable options for Kelli.

Throughout Kelli's life, I was sometimes able to work part-time jobs, if my schedule corresponded to hers. It is so important for parents of special-needs children to develop other interests and activities in their lives. These other interests can provide a healthier attitude and may help mothers not to become [s]mothers. This is good for the child and the marriage.

During the time of so many changes in Kelli's life, we were not spared normal changes and problems in our family's life. Our parents were growing older and responsibilities arose for us there. We were dealing with our own mid-life changes, including Gene's early retirement to protect Kelli's health insurance. We were beginning to think more and more of our future and especially of Kelli's future. Statistics show the divorce rate to be very high in families with handicapped children. The constant stress-drains on a marriage in every way. If you can't "pull together," it can and will pull you apart. The body and mind grow tired like everything else. Being weary and tired as a parent really has nothing to do with love. We were not given a discount rate on physical energy just because our child requires more than normal care. Until you have been responsible for another person twenty-four hours a day, seven days a week, fifty-two weeks a year, you have no idea how tired and drained the body and soul can get. Just because parents get tired and weary does not mean they love the person any less. They should not feel guilty. We are just normal humans, with limits to our physical abilities.

11 Who Will Tie Kelli's Shoes in the Morning?

I guess the most painful question asked by parents of handicapped children is, "What will happen to my child when I am gone or no longer able to take care of him?" That is in the back of your mind hovering over every stage of your life. Since we had no other children and neither of us had brothers or sisters, that has always been a painful question for us.

After Kelli had been in the sheltered workshop between two and three years, she seemed to have reached a plateau. There was not a lot of the work available that Kelli could do. Since her hands mirror (both do the same movements at the same time), it has always been difficult for her to do detailed movements. Her eye-hand coordination is very poor. What she mentally knows how to do, she cannot always physically perform. Her experience at the workshop was as unique as her school experience. Some of the instructors were very creative and always had something interesting for Kelli to do. However, some of the instructors were not as creative or involved. She became bored easily and lost interest. Some weeks her pay check, which she was so proud of, was in the amount of $.52 per week. While this did not bother Kelli, it was certainly demeaning and painful for us as parents. We began to weigh whether she was getting as much out of these days as we were putting into them.

At about this same time, Kelli began asking to move to an apartment. She had heard other people talk about leaving home and moving out on their own. She had these same desires. On two different occasions, she packed her clothes (all shorts, no underwear), and started walking up our street. She had a lot of frustrations building up inside her and we could see this, but did not know what to do.

We had always determined in our minds and hearts that we would keep Kelli at home with us as long as physically possible. We never gave any thought to any other arrangements. During this time of Kelli showing boredom and restlessness, one of her counselors at the workshop asked us to consider visiting a private group home that she had recently found. Neither Gene nor I could even talk about this without falling apart. We finally agreed to visit but that was all we would do.

When we arrived, the setting was quite different than we had ever anticipated of a group home. It looked like any neighborhood you might see going down the road. There were five ranch-style houses, with no signs or anything to indicate it was anything but a standard neighborhood. We were given the tour of all the houses and told about the individual programs. All during this time, there was no thought in our minds, except, "Yes, this is what we would like for Kelli when we are dead, but not now."

When it was time to leave, Kelli begged to stay. The administrator suggested Kelli come for one night, and see what happened. After we got home, and talked about it, since Kelli was begging, we agreed to let her go for one night. Before she was to go, I made every kind of investigation possible about this facility. This included calling the Governor's office concerning the licensing and facility evaluation. I called or went to every person I knew that had ever had any association with the people. Unfortunately, I could find nothing negative that I could use as an excuse not to let Kelli visit.

The night Kelli visited overnight was one of the longest and most heart-wrenching nights I have ever spent. There were no tears left in my body or soul. I felt as if part of my body had been taken off and I could not take care of it. When we went to get Kelli, she did not want to come home. She had made new friends and she saw this as a new experience that was certainly exciting. At home, she did not have option of nearly as many activities and friends.

After this visit, the administration suggested that Kelli visit for one weekend, then for three nights, then four. With our minds and hearts in our throats, we agreed to let Kelli "try her wings." Everyone was accepted on a ninety-day trial, meaning the program had to be what they needed and that they could maintain the program.

When I got her clothes ready to go, I only packed a few, because I was sure she would be back shortly. I took personal things that I thought Kelli might be made more comfortable with, placed pictures, etc., in her room. There is no way to describe the pain Gene and I both felt when our car pulled out of that drive with Kelli waving to us. Yet the pain we were to feel in the next few weeks was at times unbearable. Never have I been in a house so empty. Never have I seen a daddy, a dog or a mom so depressed and empty. The agonizing pain we went through was indescribable. When I left the house, there was nothing to come home to. The pain Gene was feeling was just as deep. A song that was Kelli's favorite came on the radio—nothing but tears. A program came on TV that Kelli liked—more tears. Some meals I could not cook; they were Kelli's favorite. All of our friends and most of our family were supportive. Some were not, only condemning us for something they had no idea why we were doing.

The questions we had to ask ourselves had to be unselfishly answered. Should Kelli not be given the same opportunity as any other young person to try her wings? Would it be better to make this decision while we had each other and both had our health than to wait until we had to make such a decision because of death or health? What if, at that time, such a facility was not available and Kelli had to just be placed anywhere there was a vacancy? If we made Kelli stay home, and she became more and more unhappy, what then? (Anyway, we could always reverse our decision.)

Kelli came home every weekend and always wanted to know when she could go back to the group home. Then "we" graduated to every other weekend. Kelli was now receiving so many opportunities we could not give her at home. She knows she can come home anytime she wants to. We call her at least once a week, and visit her on the weekends she doesn't come home. She has to go shopping and out to eat using "her" money. It makes her feel independent to be able to spend her money.

Kelli has made her own decision about going to the group home. She has been told by us and the staff that she has two homes now. I still cannot believe Kelli does not have to depend on us for her survival. I realize we probably needed Kelli more than she needed us at times, and to keep her homebound would be selfish. This has been the most difficult decision we ever had to make.

At the ripe age of eight months, Kelli could sit alone. It did take a lot of muscle to support those rolls of fat ("tootsie roll arms").

Fitting glasses with lenses about the size of a nickel was a real challenge, but worth it. Kelli was immediately aware that the glasses improved her vision. There was no problem keeping the glasses on, except when she wanted to cut her teeth on the frames.

"Surely Christmas is more fun than this man in the red suit with the funny beard that just tickles my nose!"

Kelli's first birthday, May 13, 1968.

Early in life, Kelli learned that prayer was something she needed a lot of—so did Mom and Dad!

Anything with wheels we either bought or made to enhance Kelli's muscle movement and muscle tone.

Kelli was a member of the Girl Scout Troop Mom and Dad helped to organize.

Kelli's pets have always been important to her, like her dachshunds Sugar Muffin and Heidi.

Camps for the handicapped always proved fun for Kelli. She has a special love for horses, which she learned to ride at camp.

Whether we went to Disney World, Disneyland, or Hawaii, Kelli always had fun. Exposure to travel enhanced Kelli's abilities and enthusiasm for life.

Class Day

At twenty-one, Kelli graduated from the special education class in the public education system.

Kelli's senior class picture.

But this child was not supposed to have lived one year! Kelli in her prom dress at twenty-one.

Kelli now has Home Number 1...

...and Home Number 2.

Gene, Kelli and Martha Clodfelter

Everything is not perfect at the group home, but it is as near perfect for Kelli as could be. I have to evaluate whether it is more important for Kelli's closet to be in order as I would have it at home or for her to be achieving her full potential in life. To know Kelli can survive and will be taken care of when we can not be with her is the greatest consolation and comfort we could have. We could never express our gratitude for such staff and programs as Kelli is receiving now. She is riding horses, swimming, has speech therapy, horticulture, aerobics, and so many social activities she could never have at home. We know all group home experiences are not positive. Every time our car leaves that driveway, a part of our hearts stays there.

Knowing all of this does not take the pain away. It just reinforces the fact that God has always taken care of Kelli and always will. A prayer is always in our hearts for her safety and well-being. Our adjustment is still gradual and is still painful, but proud. Fortunately, I have an interesting job that helps and outside interest in things I have developed through the years. At this time in our lives, we would normally be enjoying our grandchildren and all their activities. This means we still do not "fit in" in most social situations. We do not have this in common with other parents. It hurts!

12 One Year with the 'Empty Nest Syndrome'— Who Me?

For many years, I listened to couples our age when they complained about their children leaving home. My! How I have wished for my daughter to be able to leave home and live an independent life without our help.

Now it has been one year, since that difficult decision for her to try her wings. In some ways it seems only six months and in other ways five years. She has just completed her one-year evaluation at the group home. As I sat there and listened to each of the personnel give their glowing reports of Kelli's progress and her adjustment, I just want to "crow." Here is this person that God placed in our care for twenty-five years who that was not supposed to live one year and if she did was not supposed to be able to even sit alone. She had made progress in every area of the evaluation. In some areas, she had progressed from 70 percent to 90 percent. Of all the reports and comments this dedicated staff made, the one that I am most proud of and thankful for is the one saying "Kelli is a happy person and is well-adjusted in every way." I wonder how often that is said about us "normal" people?

Even with all the pride I share with Gene, the loneliness and emptiness in our lives cannot be described, now that Kelli is on her own. We go out a lot just to avoid being in this empty house now. She is functioning to the best of her ability and to her fullest potential. She is bonding with friends and now has a real extended family. The pain is still there, just as real as it was twenty-four years ago. I can't help thinking, as I listen to the reports, that I should be attending her college graduation, or helping with my

first grandchild. My best friend's daughter just got married. Kelli does not understand why she cannot marry her friend. Then she wants to know when she can have a baby (even to the point of stuffing her clothes with pocket books for her stomach). Instead I am listening to how Kelli cannot try her shoes yet, or has trouble with her spoon and fork.

The pain never goes away, but I have been made into a stronger individual because of her. She has taught me lessons in life I could never have learned without her. However, there are no words to express my pride and sense of fulfillment in hearing about her accomplishments. When we go out to eat, Kelli wants to pay with "her" money. How my pride swells when she meets us at the door to go out and says, "How I wook (look)? I dressed myself." I truly know what the phrase means, "You've come a long way baby!!!"

Recently, we saw a beautiful example of total acceptance and real bonding with Kelli and her roommate. They had both been home for holidays and were just seeing each other for the first time. They embraced and were telling each other how much they missed each other. They saw no color, no handicap, no label—it was total acceptance of each other for the person they saw and knew within themselves.

Life has not been what I would have planned or wished it to be for Kelli or us as parents. We never had the white picket fence, rambling roses, a boy, a girl, a dog, a cat—"the Brady Bunch" family. Through Kelli's life we have gained insights into realms of happiness, joy and friends we could never have had. Our life has certainly taken a different path, from what we planned. When I hear one of Kelli's friends lives in the same house say, "Kelli makes me laugh every day, I love her," I know her life is and has been a blessing in this world. How many people can make the same statement about me?

13 But I'm Not a Lawyer, Just a Confused Parent

So many decisions are involved with the disabled, most of which they themselves are not aware of. The law can be very cruel to these people. In most states it is illegal to perform sterilization on minors, as well as on retarded adults. Parents and guardians need to be very careful in handling these issues. It is painful enough for us as parents to realize Kelli is not mentally capable of parenting a child, eliminating any hope of our having grandchildren. Parents of "normal" children take all this for granted.

At our age now, all our friends are talking about their grandchildren. What do we talk about? You never quite "fit in" in most conversations. While it may be illegal for sterilization of the retarded, should they become pregnant, the child is usually removed from the family, deeming that they (the retarded parents) are incompetent to care for a child. Why can't the welfare of the retarded or disabled be more realistically considered on this issue? Most doctors and attorneys are not very knowledgeable on this subject.

Another difficult decision for parents of the disabled is the issue of legal guardianship. Some feel this is taking away their rights. I, personally, feel it is to protect their rights. We tried to investigate all the ramifications, and decided it was for Kelli's protection for us to obtain legal guardianship. If this is not done, in most states, these innocent people can be at the mercy of society. Questions parents need to evaluate are: Can this person make sensible medical decisions about themselves? Can they handle their finances if we are not there? In most states, at the age of eighteen, you are considered an adult regardless of IQ or ability.

Just because you are their parent, you may not be able to make these decisions. After eighteen years of age, most hospitals will ask if you are the guardian and not if you are the parent. On a recent visit to an emergency room, while on vacation with Kelli (she had fallen and broken her arm), I was asked to sign as her personal representative, not as her parent. This could be very complicated if there is no legal guardian.

It is not a pleasant experience to go through. The pain, once again, never stops. I knew I was acknowledging to the world that my child would never be able to be independent. While I knew it in my head, it is hard to see it printed in black and white, and admit it in your heart. There are eighteen inches between your head and your heart and sometimes that is a painful eighteen inches. I knew I was admitting that all the dreams and hopes I had for my child would never come true. Fortunately, I was able to represent myself and did not have to pay attorney fees. The courts appointed Kelli an attorney. She was a very special female attorney and helped all of us get through this experience. North Carolina does not allow for dual guardianship. Because Gene travels out of town some, and might not be available in an emergency, I was appointed. Parents need to investigate the types of guardianship, such as guardianship of the persons or guardianship of the property. This may be one person or two different persons. This is always an action of the courts, which try to look out for the welfare of the one for whom the guardianship is being granted. Here again, some doctors and attorneys need to be better educated in helping parents in this situation.

Wills and estates for the handicapped can be very difficult. The wording is so important. In order to eliminate the disabled losing benefits from government agencies after the parent's death, you may need to leave estates or trust to be used "as a suplement to other benefits." This way, the personal estate (or any monies) would not be depleted before they receive any government benefits. By doing this the disabled may have more finances for personal needs or leisure for a longer period of time. In most cases, more than one guardian needs to be appointed, in the event of the guardian's death or lack of ability to care for this person.

If there are siblings involved, parents might need to consider who the sibling should marry, the condition of their health, the condition of their finances, if they plan for siblings to take over

this responsibility. Is this really fair to this brother or sister? There is no way of knowing what the future holds for them and their family. You have no way of knowing what their finances or health may be in years to come. There are always unknowns for every family. The family with a disabled member is probably more vulnerable to the "What ifs?"

14 Daddy's Girl (from a Dad's Point of View)

I can still remember holding our bundle of joy in just one hand. She was small enough that my hand completely supported her head, neck, and enough of her shoulders. I knew she was small, but so was Martha, her father, and her grandfather. Being genetically small was a trait in Martha's family. We were so happy that we didn't suspect anything could possibly be wrong.

When you are hit with a sledge hammer right between the eyes, it does have a way of getting your attention. Yes, Kelli's problems were real and our lives would be changed forever. To say that we were not disappointed and deeply hurt by her problems would not be true. But we determined by the grace of God we would "major" on the things Kelli could do and "minor" on the things she couldn't.

Martha stayed at home and bypassed a career. We lived on a tight budget with one income at a time when the norm was a two-income family. I believe that Kelli's determination and attitudes are what they are because we made this choice. Martha was able to work with her and give her the time that she would need. I would come home after a day of work and help her with the activities that she had been working with all day. With Kelli the gains were slow and often very small. But, gains they were.

I was fortunate to work for a large corporation and had good insurance. As we were to find out later, there would be avenues that would be closed to Kelli because I made a little too much to receive help. Yet, I didn't make enough to pay for it, and virtually no insurance would pay for it. This always puts those involved in a mixed emotional battle. We wanted to do everything we could to help Kelli fulfill as much of her potential as possible. I

really felt let down by agencies that I had given financial aid to; now that I needed it. I could get no aid from them. In some cases the only help available at any cost was from these same agencies. You wonder, why can I not get the help for my child that she needs. It was through the continued searching that we found new avenues of help. Some of it from areas we never even dreamed of.

When Kelli started at the Montessori kindergarten, I had to miss her excitement because I was on a company trip to Boston, Massachusetts. I had to share this special time for her over the telephone. It was this special start in school that made us realize that Kelli could learn if only her teachers would find ways to reach out to her, ways that were not necessarily those found in the books, but that used some imagination to come up with new ways to do old jobs. We saw this approach used here and at other places with good success. I realize that Kelli has limitations in what she will be able to do; to do otherwise would be sticking my head in the sand. I have always been proud of her every accomplishment, and both Martha and I make sure she knows that we are proud of her. What is automatic to most of us can be a gigantic hurdle for her, and if you try to measure what she has accomplished against others her age, it may not seem like much. I think that God looks at what we have done with the tools we are given. If we use those tools to the best of our ability, he is pleased with us. It really doesn't matter that much what man thinks. People would look at me like I was a nut when I would tell them of new things Kelli could do. They didn't understand the effort she had to make to accomplish these things. Whether they understood or not didn't matter; I did and I was proud of her.

We were privileged to witness God perform miracles in and through Kelli. I mentioned the opened door at the kindergarten, but there were many more that we recognized even as they were happening. The business trip to New York City that resulted in our finding the TEACCH program, which was in its infancy and located in our own state; Kelli's acceptance into the program even though she was not autistic; the young graduate student who was so creative in his design of activities to help Kelli progress toward her goals.

We were making two trips a week to Chapel Hill, right in the middle of the gasoline shortage. Every trip (180 miles round trip)

we would wonder where we would be able to get the gas for our normal driving and the next trip. It was an adventure in faith, as each time something different would occur. The timing had to be perfect, and it always was. We would pass a gas station on the way back and see someone come out and get in his car and pull up to the pump. We would stop, turn around, and go back to find that this station was opening its tanks to pump gas for the day. We would fill up and be set for the next trip.

A station near our home stated it would open its pumps at 6:00 pm and pump until they ran out. We were 74th and 75th in line. I filled car number 1 (# 74) up, pulled car number 2 (# 75) up to the pump and filled it up. The tanks ran dry with the car number 76 at the pump.

I had to be off two afternoons each week to carry Kelli to Chapel Hill. If forced to take vacation time off, it wouldn't be long before I had no vacation left. My boss agreed to let me come in to work after we got home and work the time I was out, on second shift. This meant that he had no idea whether I did or did not come in since I would be working alone. He agreed with no questions asked, even though we did not get along very well in several areas. I do not want it to sound as if everything was all roses, because it was not. These trips and the work with Kelli every day wore on both Martha and me.

I will not bore you by listing each and every occasion in her life that we have experienced. We did not have a big fancy house—still don't have a big fancy house—but our home was sufficient. We did not own the finest of cars, but we had two good cars. We took modest vacations and I think we were good stewards of our money. This experience was not what we had asked for, but it was one which certainly brought us closer to God. We could have moaned and groaned about things not being fair, but that never gets anyone anywhere. There is no such thing as a level playing field. Each one of us is an individual. We have our strengths and our weaknesses. We are not exact clones of each other. What a boring life it would be if that were true. I miss Kelli's presence at home every day, and most of all I miss her laughter.

Fathers go through a different kind of emotional stress. They also show it differently than women. A lot of men have trouble crying. I can cry, but it may not be at the time the event is occurring. I probably cried more while driving to and from some outlying job location. Sometimes it just builds up too much inside

not to let it out. I cried a lot when I knew she was going to the group home. They were mixed tears of joy and sorrow. It was not easy to let her leave to go live in a group home, but for twenty-five years we had diligently worked to help her develop into a young woman and to be as independent as possible. Through tears Martha and I discussed the prospect of Kelli taking this big step. Yet, for her it meant a life of fulfillment where she made her own friends and bonds with other young adults in her age group. We are very proud of her and her independence and often tell her so. She is proud of herself because she knows it was her decision. She made it and it would have been contrary to all that we had tried to teach her for us to have denied her the chance. We were told that she probably made the adjustment better than a lot of others living there. It does give us a sense of relief knowing that if and when something happens to either or both of us, Kelli has already made her adjustment. I would have chosen a different path to travel, but it may have been one that contained more heartache and sorrow than we ever dreamed of. There is a saying "Let loose and let God." That is what we tried to do. I hope I can touch as many lives in a positive way as Kelli has touched.

15 Insights: A Look Back

1. The things we expected to be important are not as important now.

2. Be extremely thankful for small things. Do not take anything in life for granted.

3. Ignorance can be the biggest hurdle of all. Public, friends, family, church, doctor, etc. Out of lack of knowledge, sometimes there is a stigma attached to these families that is hard to live with and overcome.

4. Doctors are human and do make mistakes. Yet they want to learn and help, and they can do much to help families cope with the emotional issues they constantly deal with, as well as medical issues. As one dear pastor friend once told us, "They are just practicing medicine, they have not perfected it yet."

5. Churches can be a great disappointment in their lack of true caring. Sometimes they offer pity instead of concern. There is a great difference between the two.

6. Help comes from unexpected places and people. Remember, God is not limited.

7. God does not plan imperfect bodies, as such. Nature is nature. There are imperfect genes in all of us. The miracle is that the percentage of problem births is as low as it is.

8. God's doesn't measure us by what we don't have, but rather by what we do with what we have. A doctor once told us that if

we "normal people" would use as much of our potential as Kelli used of hers, there is no limit to what we could be. The general population is said to only use about 10 percent of potential brain power most of the time.

9. Animals (pets) have always been an important part of Kelli's life. There is a special companionship and understanding between them.

10. Miracles do happen all of the time. Kelli's life is full of them. The problem most of us have is that we do not take the time or make the effort to realize or see them for what they are.

11. God gives us talents to use. Kelli's strongest talent is "love," totally uninhibited. She has used it from the beginning.

12. Giving a problem a label or name does not mean that it will go away or get better. We have seen this cause separation of people, when they should be supporting one another. When parent groups become fragmented, we become our own worst enemies. Parents have to work together to help one another. Retardation and handicaps are problems enough. Some think that their problem is different so they do not support the other handicaps. The world as a whole is not overly sympathetic to the needs of the handicapped and when we start separating ourselves, we make our own cause even more difficult.

13. Sometimes much of the available help is either misdirected or misspent due to lack of understanding. Public education is still a great need. At times, we have found that the mentally ill and the mentally retarded are "lumped" together in programs and in funding of some programs. These are two entirely different diagnoses', and should not be thought of as the same in terms of expectations.

14. We as parents need to search ourselves to be sure we allow our children to grow up and expand their horizons to their fullest potential. It is easy for our personal need and pride, even greed, to get in the way. There is a fine line to determine what they can do and what we want them to do.

15. Most of the time it is much easier for parents to keep them at home than to keep them involved in the special programs that are available. This then becomes a great discouragement to those organizations that would start programs for the handicapped.

16. Churches as a whole, may be missing out on the blessings of the handicapped. They can be a great ministry to the church, not just a ministry of the church. There is a difference in providing a ministry and to just tolerate them because they are here.

17. Many people never allow them to grow past the child stage. It is easier to entertain than it is to teach.

18. Be proud of their accomplishments and let them and others know that you are proud of them. It builds their self-esteem. It may be a simple task, but when they give their all in trying, it is usually more than we would have done at our level of ability.

19. Parents, grandparents, teachers, and others associated with the handicapped need to analyze their own feelings and needs. Sometimes we are using them to fulfill a need in our lives and we are actually needing them more than they are needing us. This is a very selfish love, and therefore we may inhibit their growth to their fullest potential.

20. The birth of a "special-needs" child is not the end of the world. It is a painful never-ending challenge. When you have been involved in another human reaching for their full potential and finding happiness, that is true fulfillment in this life.

CONTENTMENT

She knows no envy
She only knows love;
She knows no prejudice
Her thoughts rise above.

She sees the beauty
In a simple rippling stream;
For she's often left alone
Not on anyone's team.

The warmth of a smile
She loves completely;
The simple things in life
She enjoys so freely.

She loves all God's creatures,
A warm furry friend
With a wet cold nose
She would never offend.

If I saw the world
Through the eyes of my child
How much more contentment
I'd have all the while.

For you see, she's been labeled,
Retarded, they say;
But, I wonder whose
Mind is really astray?

Is it she, or is it I
Whose mind has a scar;
I see the ground
And she sees a star!

Martha Clodfelter